Draw
Still Life

MOIRA HUNTLY

Series editors: David and Brenda Herbert

A & C Black • London

First published in 1980
New style of paperback binding 1995
by A&C Black Publishers Limited
38 Soho Square, London W1D 3HB
www.acblack.com

Reprinted 2001, 2004, 2007

ISBN: 978-0-7136-8787-3

Copyright © 1980 A&C Black Publishers Limited

Cover design by Emily Bornoff

Printed in China by WKT Company Limited

This book is produced using paper that is made from
wood grown in managed, sustainable forests. It is natural,
renewable and recyclable. The logging and manufacturing
processes conform to the environmental regulations
of the country of origin.

Contents

Making a start

Most of the world's great painters have studied still life. It can help to solve many of the problems of drawing and composition found in landscape painting and in the art of picture-making in general. I often use my drawing to make more imaginative paintings, gaining ideas from the shapes, textures and arrangement of objects that have an affinity.

Learning to draw is largely a matter of practice and observation—so draw as much and as often as you can, and use your eyes all the time. Simple objects are readily available in the home, which makes still life an ideal indoor subject.

The time you spend on a drawing is not important. A ten-minute sketch can say more than a slow, painstaking drawing that takes many hours.

To do an interesting drawing, you must enjoy it. Even if you start on something that doesn't particularly interest you, you will probably find that the act of drawing it—and looking at it in a new way—creates its own excitement. The less you think about how you are drawing and the more you think about what you are drawing, the better your drawing will be.

The best equipment will not itself make you a better artist—a masterpiece can be drawn with a stump of pencil on a scrap of paper. But good equipment is encouraging and pleasant to use, so buy the best you can afford and don't be afraid to use it freely.

Be as bold as you dare. It's your piece of paper and you can do what you like with it. Experiment with the biggest piece of paper and the boldest, softest piece of chalk or crayon you can find, filling the paper with lines to get a feeling of freedom. Even if you think you have a gift for tiny delicate line drawings with a fine pen or pencil, this is worth trying. It will act as a 'loosening up' exercise. The results may surprise you.

Be self-critical. If a drawing looks wrong, scrap it and start again. A second, third or even fourth attempt will often be better than the first, because you are learning more about the subject all the time. Use an eraser as little as possible— piecemeal correction won't help. Don't retrace your lines. If a line is right the first time, leave it alone—heavier re-drawing leads to a dull, mechanical look.

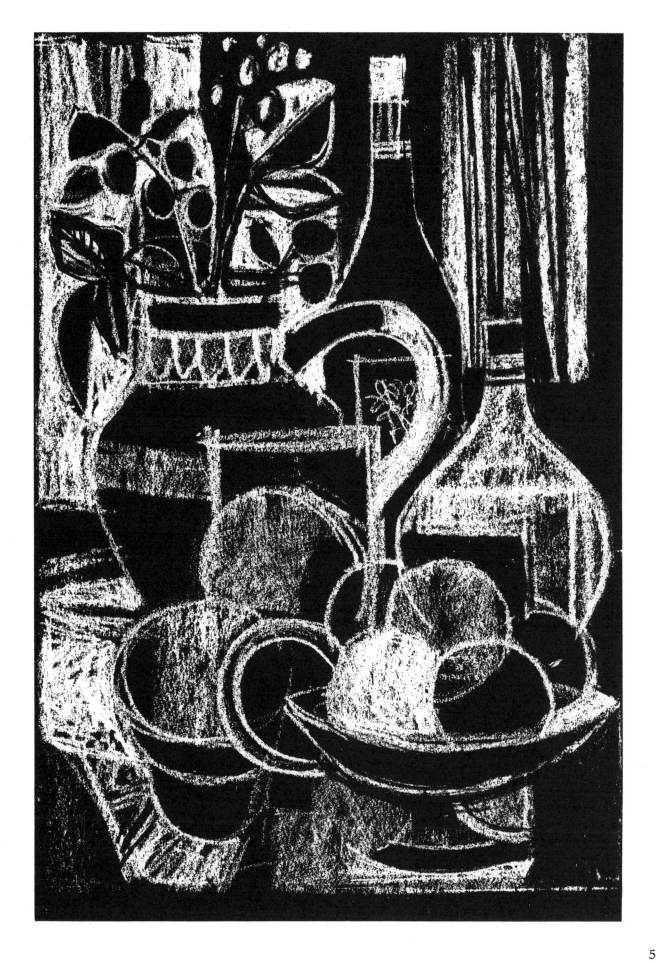

Try drawing in colour. Dark blue, reddish-brown and dark green are good drawing colours. A coloured pencil, pen or chalk can often be very useful for detail, emphasis or contrast on a black and white drawing.

A lot can be learned by practice and from books, but a teacher can be a great help. If you get the chance, don't hesitate to join a class—even one evening a week can do a lot of good.

What to draw with

CHARCOAL

PEN & INK

STICK & INK

BRUSH & INK

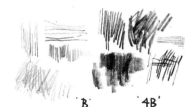

B 4B

PENCIL

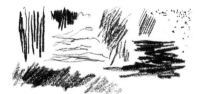

CONTÉ PENCIL

Pencils are graded according to hardness, from 6H (the hardest) through 5H, 4H, 3H, 2H to H; then HB; then B, through 1B, 2B, 3B, 4B, 5B up to 6B (the softest). For most purposes, a soft pencil (HB or softer) is best. If you keep it sharp, it will draw as fine a line as a hard pencil but with less pressure, which makes it easier to control. Sometimes it is effective to smudge the line with your finger or an eraser, but if you do this too much the drawing will look woolly. Pencil is the most versatile of all drawing techniques, suitable for anything from the most precise linear drawing to broad tonal treatment. Of course, a pencil line, even at its heaviest, is never a true black. But it has a lustrous, pewtery quality that is very attractive. A fine range of graphite drawing pencils is Royal Sovereign.

Charcoal (which is very soft) is excellent for large, bold sketches, but not for detail. Beware of accidental smudging; a drawing can even be dusted or rubbed off the paper altogether. To prevent this, spray with fixative.

Wax crayons (also soft) are not easily smudged or erased. You can scrape a line away from a drawing on good quality paper, or partly scrape a drawing to get special effects.

Oil pastels, marker pencils, chinagraph and lithographic chalk are similar to wax crayons.

Conté crayons, wood-cased or in solid sticks, are available in various degrees of hardness, and in several colours. The cased crayons are easy to sharpen, but the solid sticks are more fun—you can use the side of the stick for large areas of tone. Conté is harder than charcoal, but it is also easy to smudge. The black is very intense.

Pastels (available in a wide range of colours) are softer still.

Pens vary as much as pencils or crayons. Ink has a quality of its own, but of course it cannot be erased. Mapping pens are only suitable for delicate detail and minute cross-hatching.

Special artists' pens, such as Gillott 303 and Gillott 404, allow you a more varied line, according to the angle at which you hold them and the pressure you use. The Gillott 659 is a very popular crowquill pen.

Reed, bamboo and quill pens are good for bold lines and you can make the nib end narrower or wider with the help of a sharp knife or razor blade. This kind of pen has to be dipped frequently into the ink.

Fountain pens have a softer touch than dip-in pens, and many artists prefer them.

Special fountain pens, such as Rapidograph and Rotring, control the flow of ink by means of a needle valve in a fine tube (the nib). Nibs are available in several grades of fineness and are interchangeable. The line they produce is of even thickness, but on coarse paper you can draw an interesting broken line similar to that of a crayon.

Inks also vary. Waterproof Indian ink quickly clogs the pen. Pelikan Fount India, which is nearly as black, flows more smoothly and does not leave a varnishy deposit on the pen. Ordinary fountain-pen or writing inks (black, blue, green or brown) are less opaque, so give a drawing more variety of tone. You can mix water with any ink in order to make it thinner. But if you are using Indian ink, add distilled or rain water, because ordinary water will cause it to curdle.

Ball point pens make a drawing look a bit mechanical, but they are cheap and fool-proof and useful for quick notes and scribbles.

Fibre pens are only slightly better, and their points tend to wear down quickly.

Brushes are very versatile drawing instruments. The biggest sable brush has a fine point, and the smallest brush laid on its side provides a line broader than the broadest nib. You can add depth and variety to a pen or crayon drawing by washing over it with a brush dipped in clean water.

Mixed methods are often pleasing. Try making drawings with pen and pencil, pen and wash or Conté and wash. And try drawing with a pen on wet paper. Pencil and Conté do not look well together and Conté will not draw over pencil or greasy surfaces.

What to draw on

Try as many different surfaces as possible.

Ordinary, inexpensive paper is often as good as anything else: for example, brown and buff wrapping paper (Kraft paper) and lining for wallpaper have surfaces which are particularly suitable for charcoal and soft crayons. Some writing and duplicating papers are best for pen drawings. But there are many papers and brands made specially for the artist.

Bristol board is a smooth, hard white board designed for fine pen work.

Ledger Bond (cartridge in the UK), the most usual drawing paper, is available in a variety of surfaces—smooth, 'not surface' (semi-rough), rough.

Watercolour papers also come in various grades of smoothness. They are thick, high-quality papers, expensive but pleasant to use.

Ingres paper is mainly for pastel drawings. It has a soft, furry surface and is made in many light colours—grey, pink, blue, buff, etc.

Sketchbooks, made up from nearly all these papers, are available. Choose one with thin, smooth paper to begin with. Thin paper means more pages, and a smooth surface is best to record detail.

Lay-out pads make useful sketchbooks. Although their covers are not stiff, you can easily insert a stiff piece of card to act as firm backing to your drawing. The paper is semi-transparent, but this can be useful—almost as tracing paper—if you want to make a new, improved version of your last drawing.

An improvised sketchbook can be just as good as a bought one—or better. Find two pieces of thick card, sandwich a stack of paper, preferably of different kinds, between them and clip together at either end.

Perspective

You can be an artist without knowing anything about perspective. Five hundred years ago, when some of the great masterpieces of all time were painted, the word did not even exist. But most beginners want to know something about it in order to make their drawings appear three-dimensional rather than flat, so here is a short guide.

The further away an object is, the smaller it seems.

All receding parallel lines will appear to converge at eye-level at the same vanishing point. Lines that are above your eye-level will seem to run downwards towards the vanishing point; lines that are below your eye-level will run upwards. You can check the angles of these lines against a pencil held horizontally at eye-level.

The larger and closer any object is, the bigger the front of it will seem to be in relation to the part furthest away, or to any other more distant object. Its actual shape will appear foreshortened or distorted.

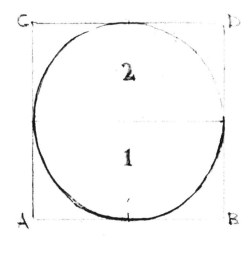

You will tend to exaggerate the apparent depth of top surfaces because you know they are square or rectangular and want to show this in your drawing. You can check the correct apparent depth of any receding plane by using a pencil or ruler held at eye-level and measuring the proportions on it with your thumb.

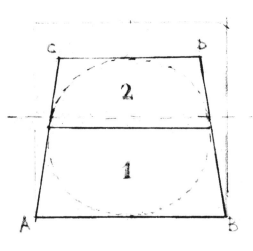

A circle in perspective becomes an ellipse. The diagrams will help you understand this. Draw a circle inside a square on a piece of cardboard, and divide the circle in half horizontally. By tipping the card so that section 2 is further away it appears smaller than section 1; and the edge CD is also further away and therefore appears narrower than AB.

In the bottom diagram, the card is tilted even further so that CD becomes considerably narrower and the distance between it and AB is very foreshortened. Section 1 of the circle remains nearer and therefore appears larger than section 2.

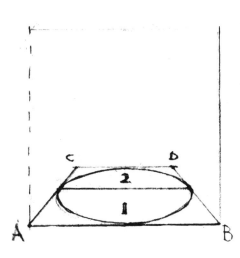

This principle can be applied to all circular objects. The axes can be drawn in lightly at right angles to each other in the centre.

The second important point to remember when drawing ellipses is to notice how far above or below your eye-level the object is.

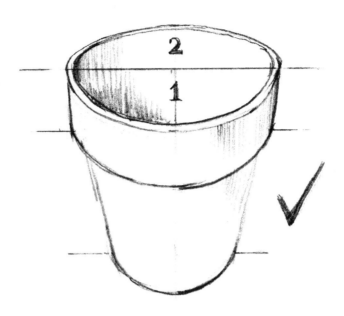

Looking down at a flower pot. The lower a circular object is in relation to your eye-level, the more you can see of the full circle; the base of the pot is therefore more rounded than the top.

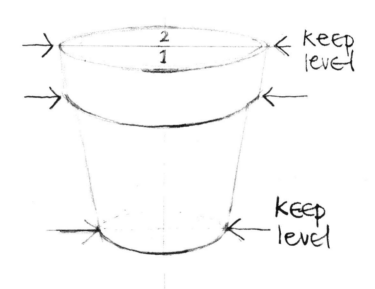

This pot is on a slightly higher level, but you can still see the inside. As before, the semi-circle nearest you (1) is the larger, but the difference is fractional at this angle. Again note that the base is more rounded.

keep level

keep level

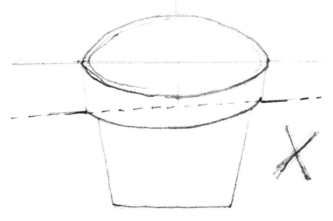

See how odd it looks if you do not obey the rules!

If the flower pot is on the same level as your eye, you will not be able to see inside. All you can see is a straight line at the rim. The next line down is imperceptibly curved and the base very slightly curved.

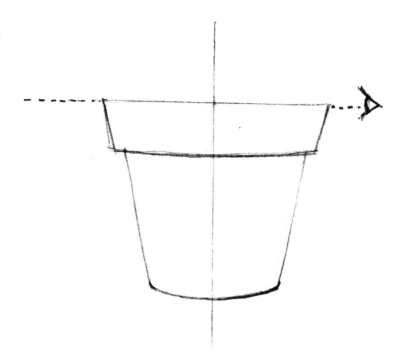

The straight line at the top in fact represents part of a circle—the curved rim of the pot. The use of shading will help to make the object look circular.

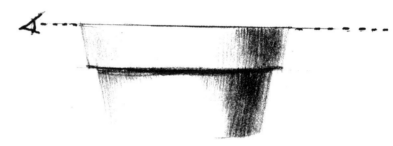

The same rules apply to the base of the pot. When drawing the base, imagine that the pot is transparent.

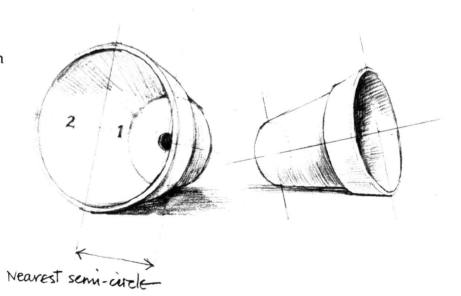

Nearest semi-circle

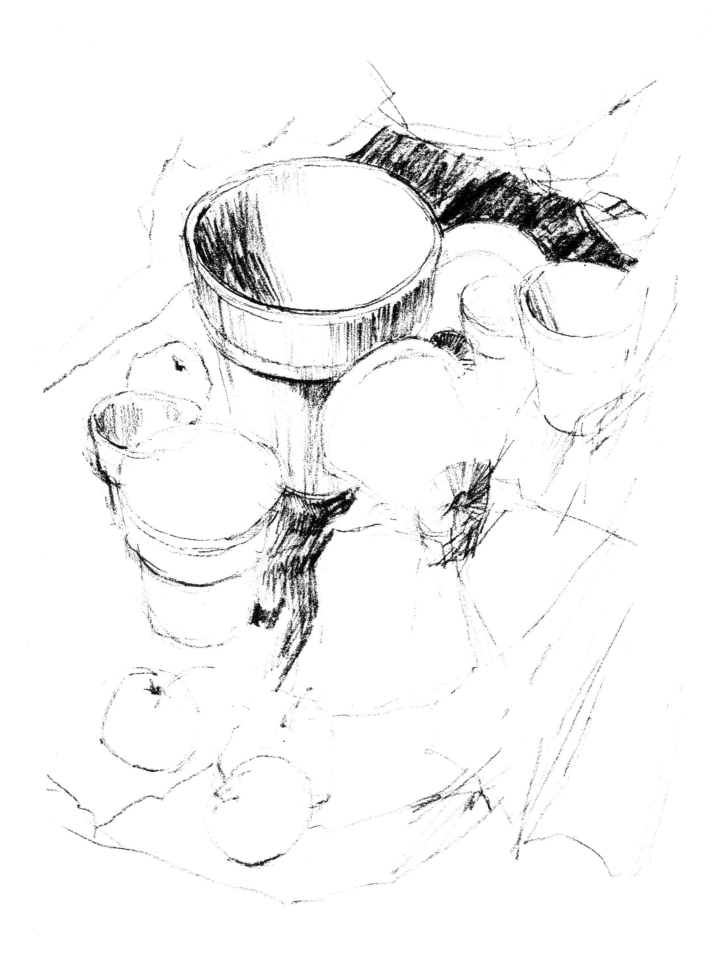

Composition

When setting up a still life group, the objects can be placed on a low table or on the floor in the corner of a room. The drawing is often more interesting if you can look down on the objects.

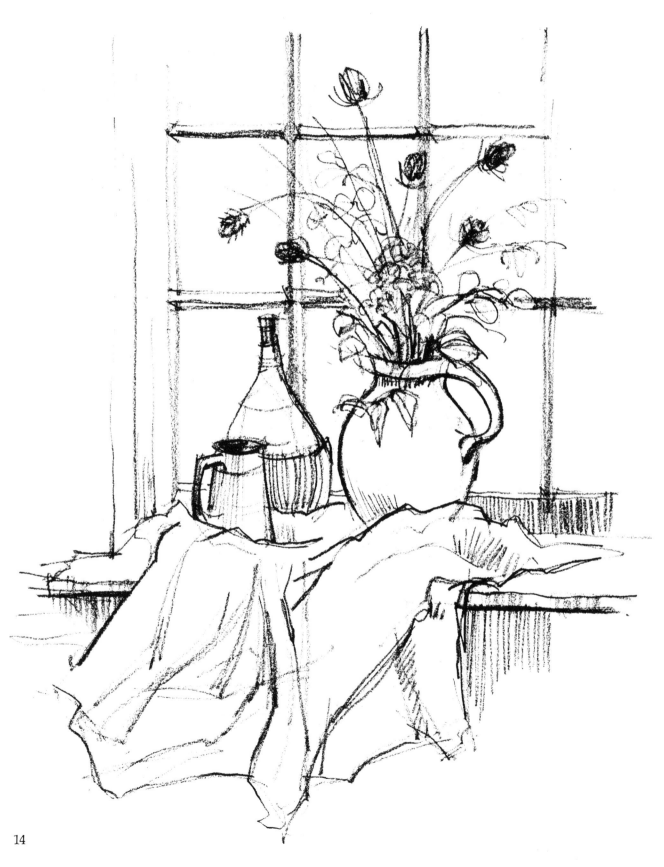

A small group could be placed on a mantelpiece or on a window sill.

This sketch shows a group arranged on two pieces of hardboard on a couple of chairs.

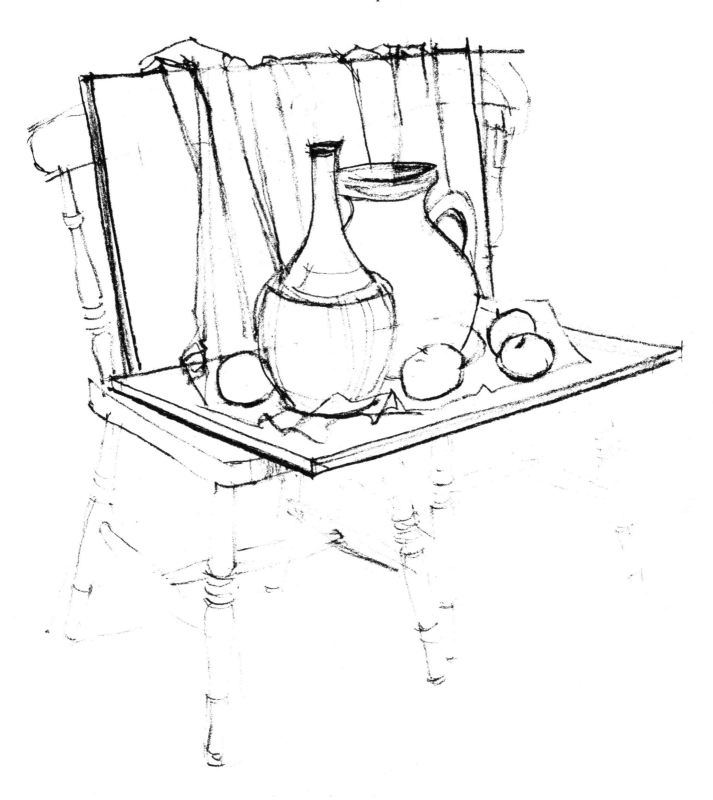

Before starting to draw, look at the height and width of each object and compare them. Lightly mark the top of the tallest object, placing it near the top of the paper and off centre to make a more pleasing composition. Then mark the outer edges of the other objects; the three objects here form an unusual triangle. At the same time try to draw the objects large enough, so that you are not left with a gap at the bottom of the paper which could unbalance the composition.

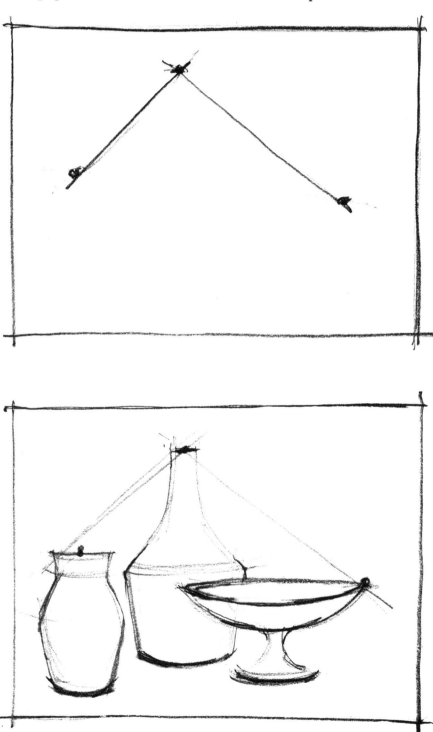

Avoid drawing the objects in a row on the bottom of the paper; and do not draw them too small. Remember that the whole area of the paper is part of the composition.

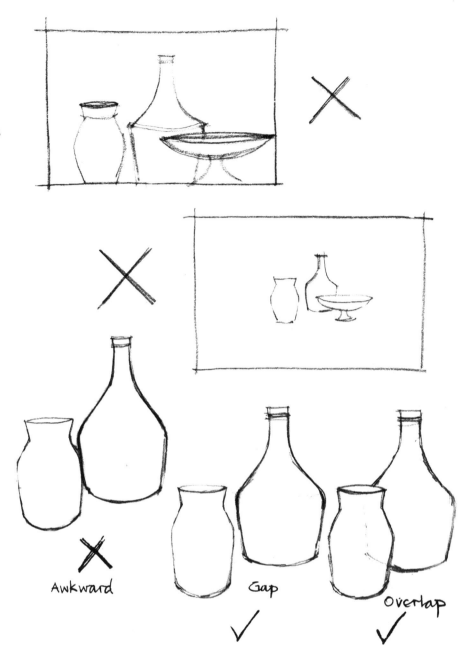

Awkward

Gap

Overlap

After arranging the objects, you may find that you have an awkward view of them, e.g. with the edges of two objects coinciding. Either re-arrange them or move your own position. Having a gap between the objects or overlapping them makes a more pleasing composition.

In these diagrams you will notice that the level of the base of each object on the paper relates to its position within the group. The nearest object is placed lowest on the paper, and the base of the object furthest away highest on the paper.

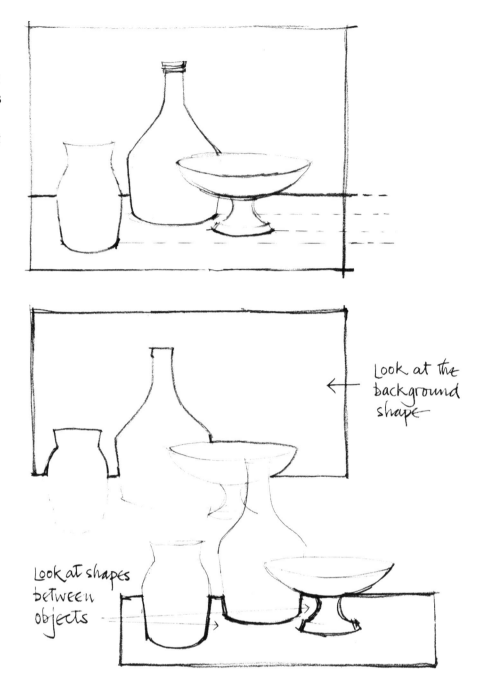

Look at the background shape

Look at shapes between objects

Having established the position of the objects, you can then decide how much of the background to include to complete the composition.

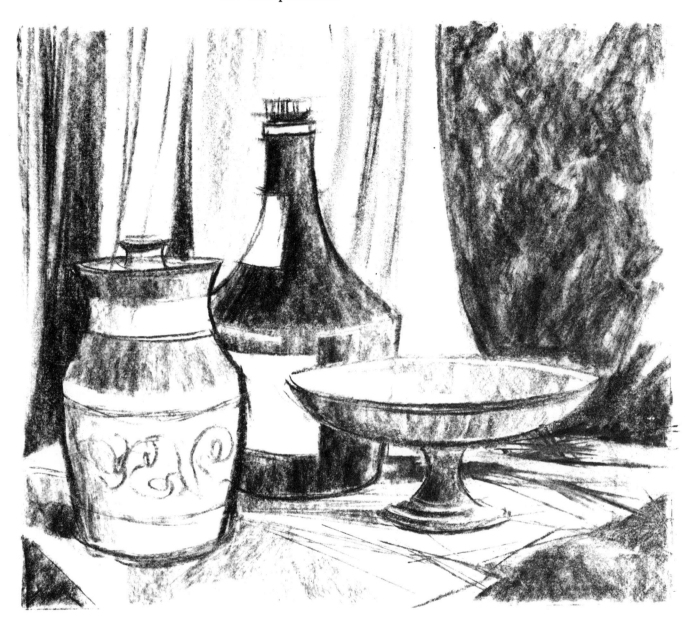

Starting to draw

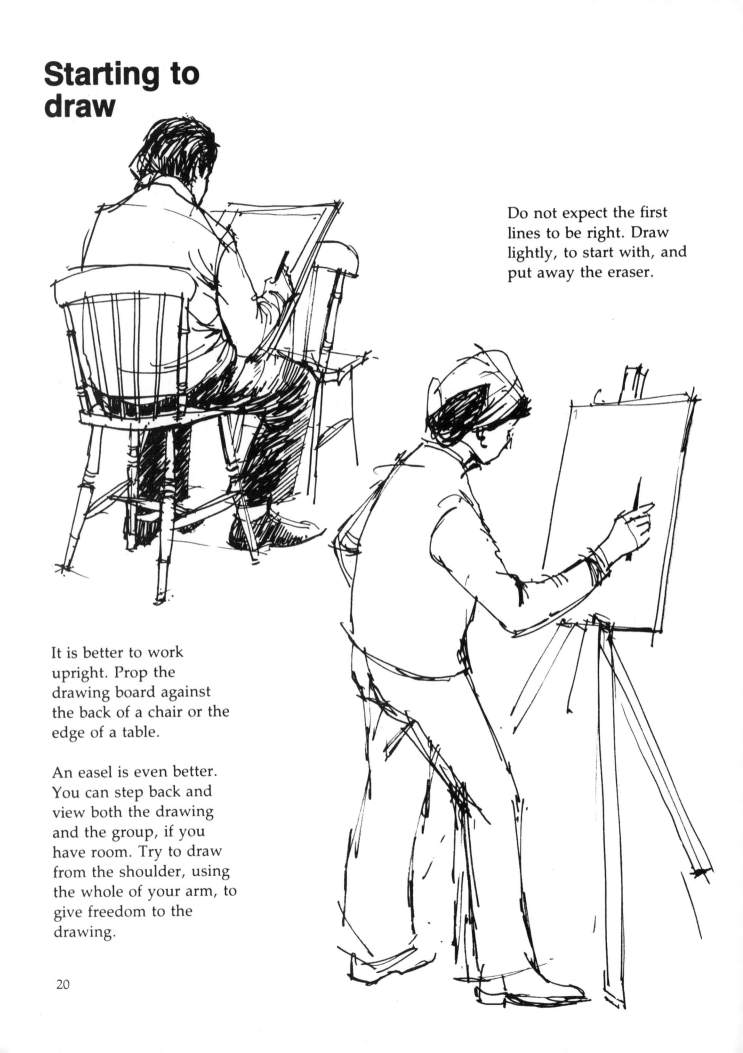

Do not expect the first lines to be right. Draw lightly, to start with, and put away the eraser.

It is better to work upright. Prop the drawing board against the back of a chair or the edge of a table.

An easel is even better. You can step back and view both the drawing and the group, if you have room. Try to draw from the shoulder, using the whole of your arm, to give freedom to the drawing.

Drawing is not like writing, so do not grip your pencil tightly. Do just the opposite—hold the pencil loosely and be prepared to change your grip.

Sometimes the end of the pencil is in the palm of the hand and the forefinger on top, and sometimes the thumb is on top. The pencil can be vertical to the paper or at varying angles.

Rest your little finger on the paper to steady your hand when drawing a fine line or detail.

Step-by-step 1: a bottle

Compare the length of the neck of the bottle with the shoulder and body. A faint centre line helps to ensure that the top is central so that the bottle will not look as if it is toppling over. It is also a way of checking that each side is equal in width.

Draw one side, then draw the second side lightly and turn the drawing upside down. This makes any faults more obvious.

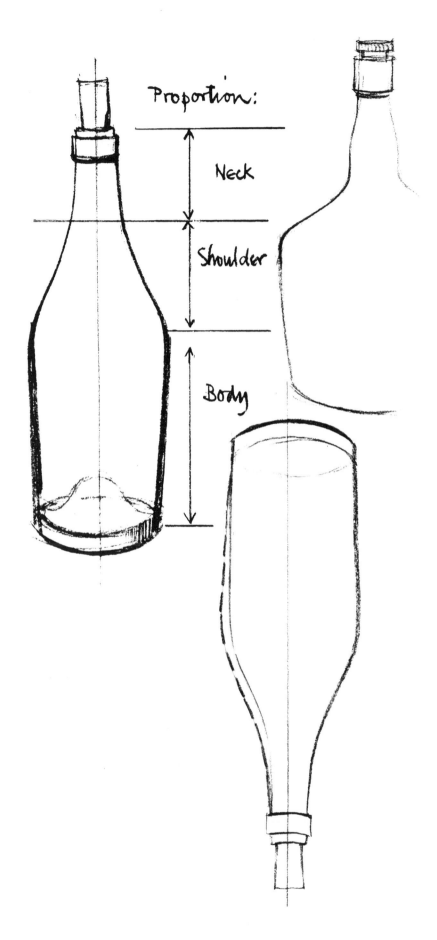

Proportion:

Neck

Shoulder

Body

This drawing was done in charcoal. Look for dark edges against a light background and vice versa. I made use of the white paper and an eraser for the the highlights. Avoid using a strong line to define shadows; a soft edge is more effective.

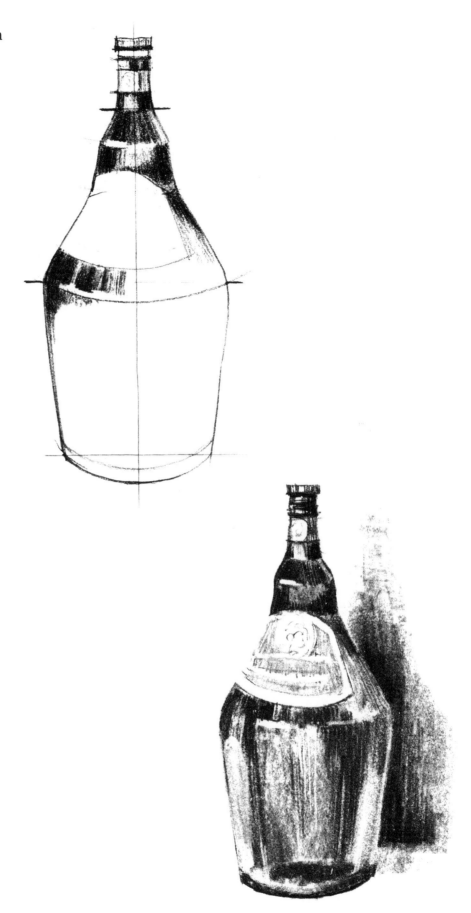

Step-by-step 2: handles and spouts

Mugs and jugs are made without a handle to begin with, then the spout is shaped and the handle is added. Remember this when you are drawing and use the same sequence.

Handles must be sturdy and have thickness as well as width. Sometimes you can see the width on the inside of the curve and sometimes on the outside. Notice how smoothly the handle is joined to the pot.

Place the top and the base of the handle in line.

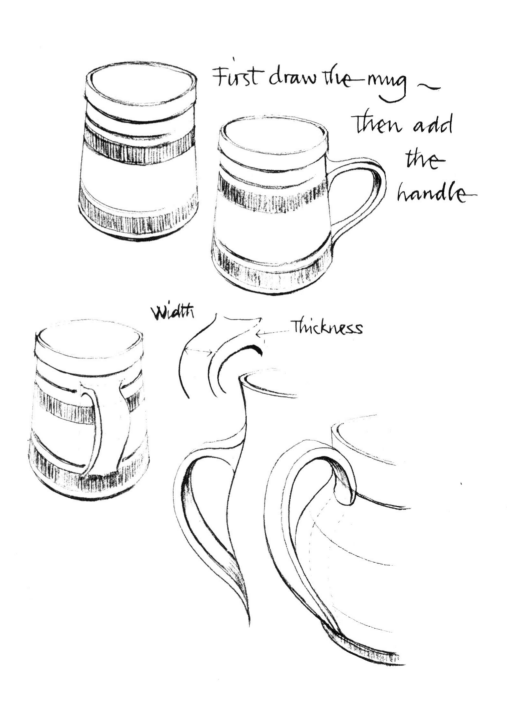

First draw the mug ~ then add the handle

Width

Thickness

Make sure that you draw the handle and spout opposite to each other. Even if you can't see the whole of the lid, draw it all in lightly so that it fits convincingly in the pot.

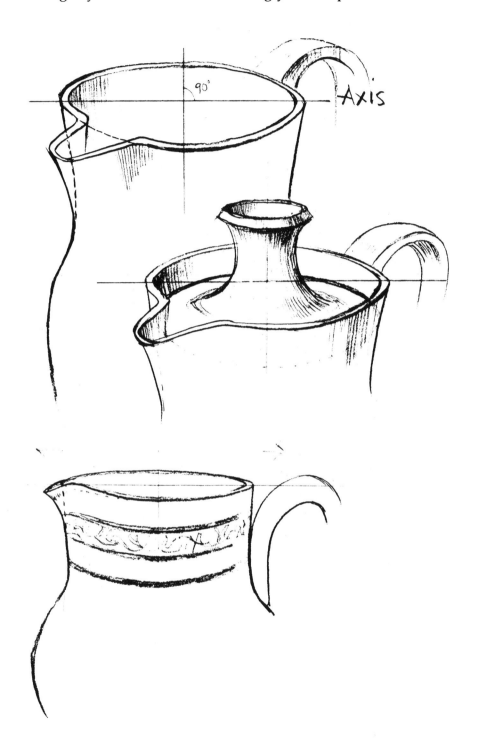

As with the bottle, a lightly drawn centre line will help to get the shape symmetrical.

The sketch on the opposite page was drawn with charcoal, sometimes used on its side.

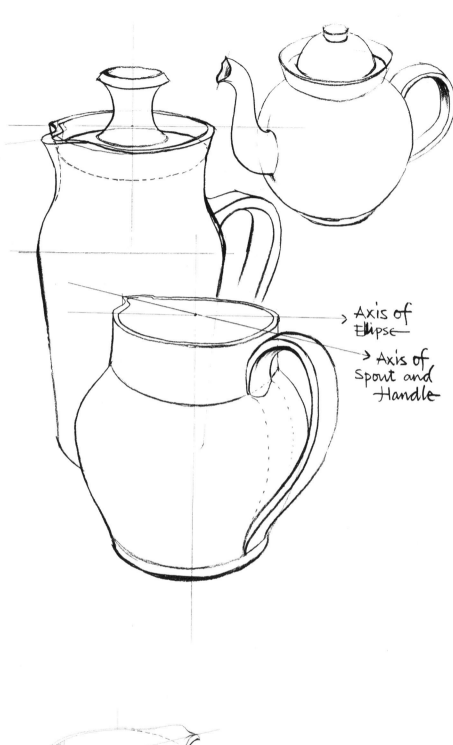

Axis of Ellipse

Axis of Spout and Handle

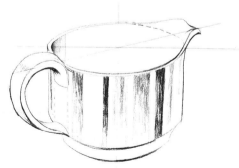

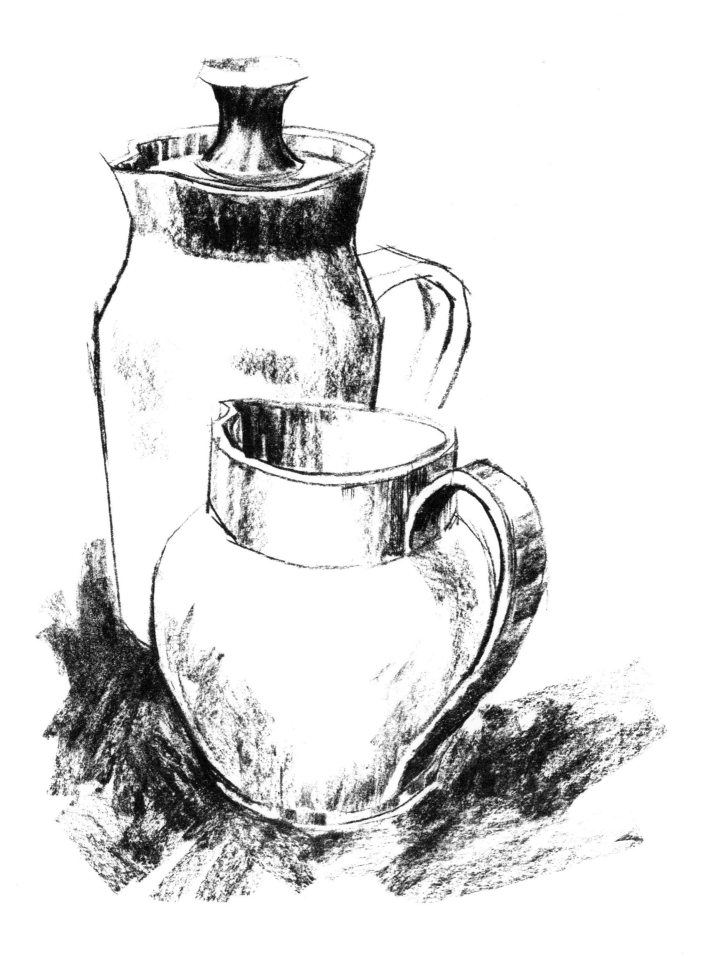

Step-by-step 3: vegetables

Vegetables have endless possibilities as subject matter in still life groups. The shapes of these onions have nice flowing rhythms.

In the group of onions opposite, I started by drawing all the outlines and then thickened up the edges that are visible.

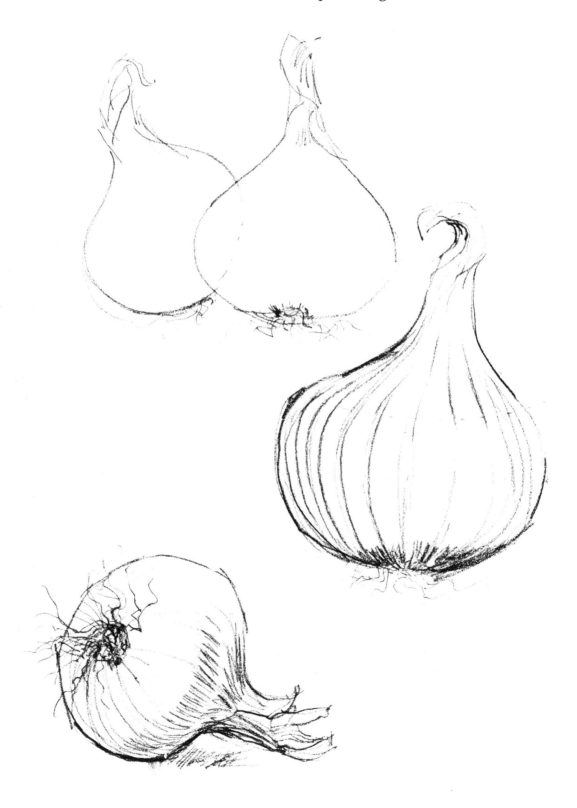

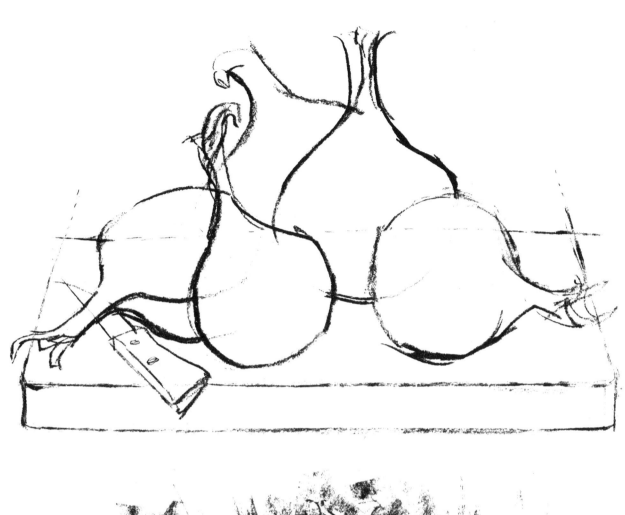

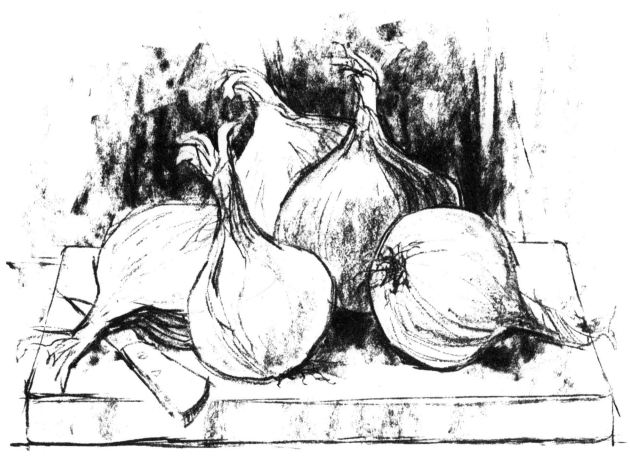

Looking at detail

This fascinating pattern of the inside of a red cabbage was drawn with a pen and ink outline. Masking fluid was then applied with a brush to the light areas and allowed to dry. Then a wash of black watercolour was applied, and when the wash was completely dry the masking fluid was finally rubbed off.

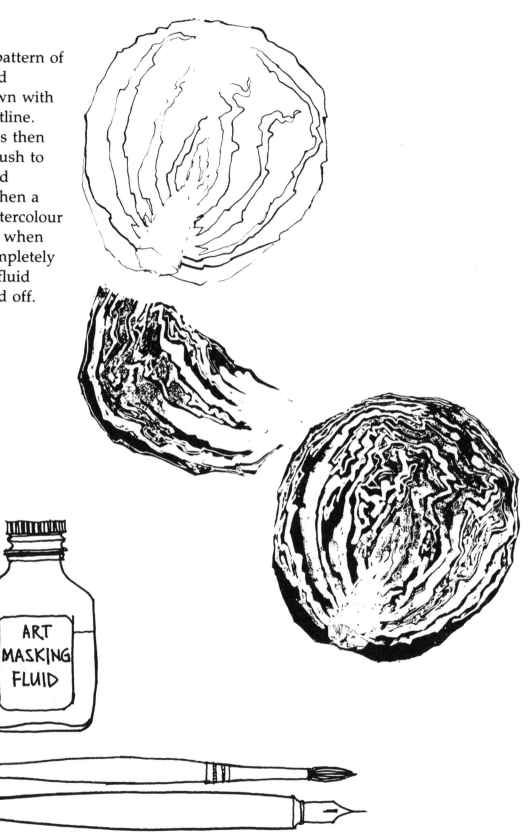

Basketry provides interesting texture and detail. This basket was drawn freely with pen and ink. Look for the general shape first and then outline the detail and gradually build up the light and shade. Objects with different textures can be a pleasant foil to the smoothness of glass or pottery within a still life group.

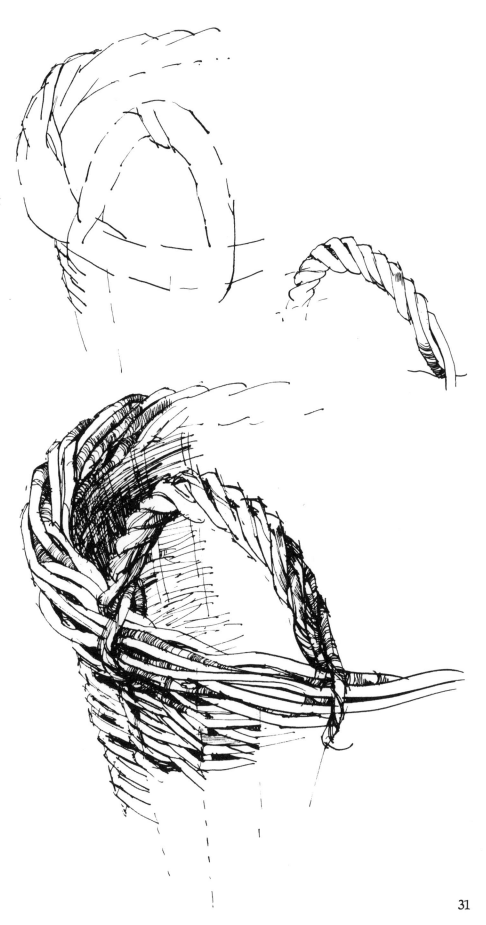

Shadows and highlights

Shading describes the form of an object. Look for the direction of light. Extra dark tone just inside the near edge of a bowl or pot will bring the edge forward; and a thin dark line under an object will 'seat' it firmly on the ground. Sometimes it is the shading of the background that describes the form, and sometimes the form can merge with the shading of the background.

Remember that the apparent edge of a rounded object is not really an edge, but the point at which the form is turning away from you; so keep the strongest darks on the area just inside the edge, which is nearer to you.

These diagrams were drawn with a B pencil.

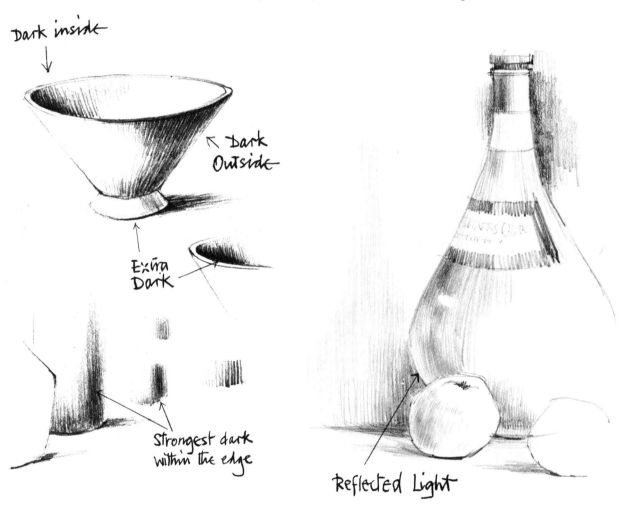

Dark inside

Dark Outside

Extra Dark

Strongest dark within the edge

Reflected Light

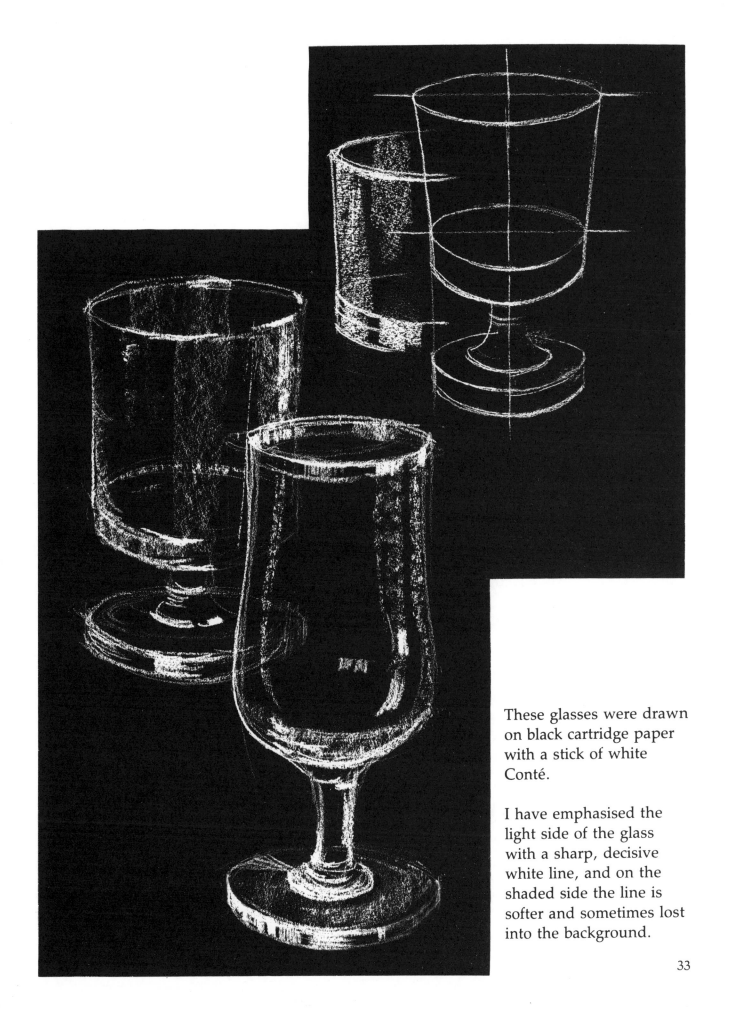

These glasses were drawn on black cartridge paper with a stick of white Conté.

I have emphasised the light side of the glass with a sharp, decisive white line, and on the shaded side the line is softer and sometimes lost into the background.

33

Extra dark tone at the base of the apple gives stability. 'Feel' your way round the subtle variation in the shape of the apple—it can be quite angular, as in this charcoal sketch.

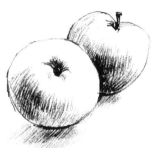

Variation in pressure can give an impression of light and shade. Don't be afraid to let a line almost disappear in the lightest areas.

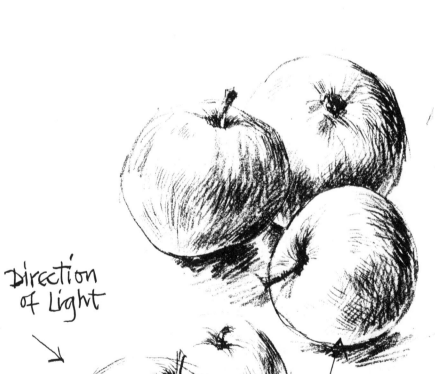

Softer line

Extra dark in centre

Strong line brings this edge forward

Direction of Light

Reflected Light

Strongest dark just inside edge. This allows the actual edge to recede slightly

Fruit has inspired many painters. I particularly like the way Cézanne painted apples. I have drawn some apples with a B pencil and some with a charcoal pencil.

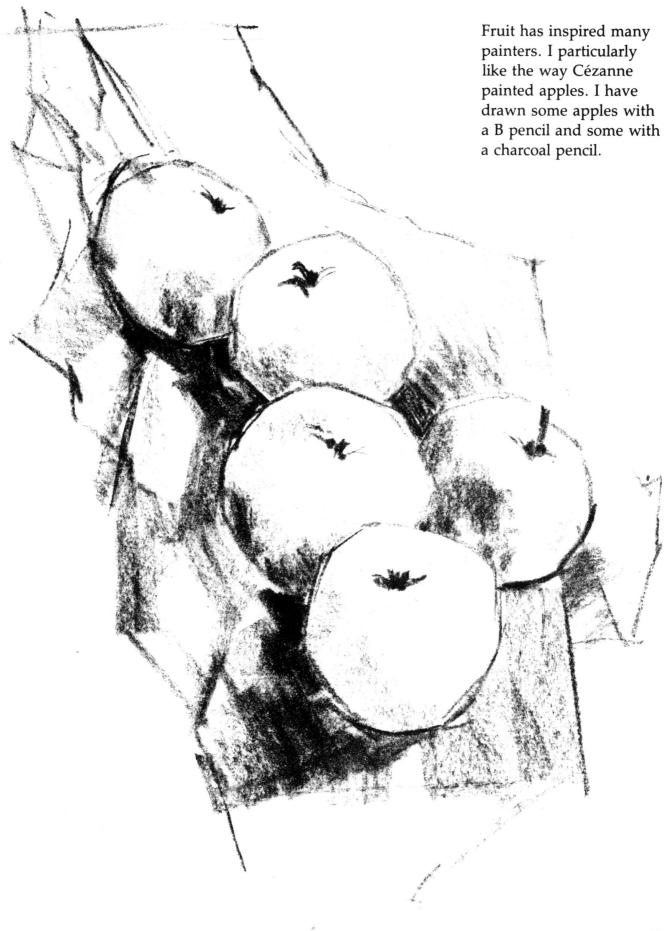

A range of tone from light grey to black, as indicated in the squares in the lower left-hand corner, can be used in a charcoal 'painting'. Varying textures can be obtained by using the charcoal on its side, and by rubbing.

The charcoal drawing opposite of a pot plant and gourds was done as a tonal study to produce light shapes against a dark background. I drew the outlines first and then filled in the spaces.

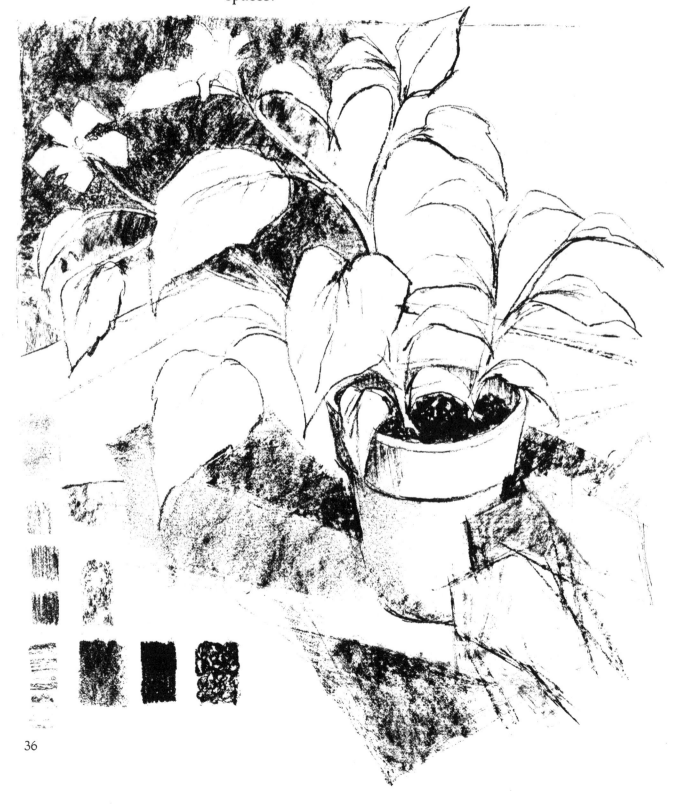

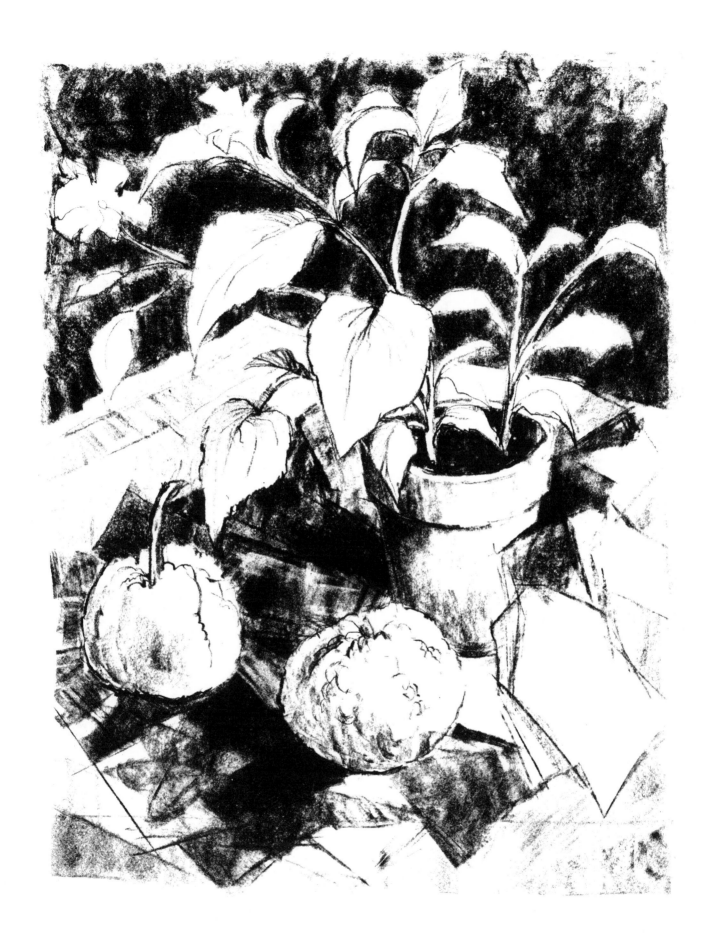

Folds

Folds in cloth or paper may seem confusing at first. For drapery, start with long flowing lines. Look for the sharp edge and the soft edge on each fold. Use extra pressure when drawing along the sharp edge, to bring it forward. These folds were drawn with a Conté pencil.

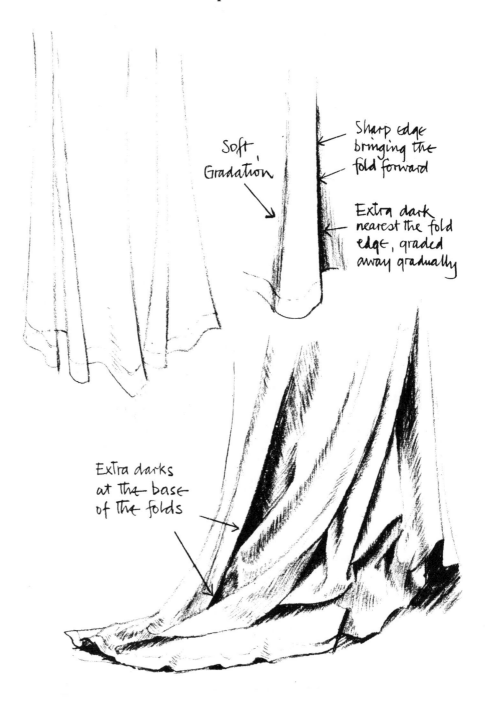

Soft Gradation

Sharp edge bringing the fold forward

Extra dark nearest the fold edge, graded away gradually

Extra darks at the base of the folds

The angular folds of the tissue paper below were drawn with a B and a 4B pencil. I started by drawing the cut edge and made it a positive line. With the B pencil I drew a series of angular planes, leaving out many in the lightest areas. By changing the direction of the shading lines, the planes can be set at varying angles. I used the B pencil for the light tones, a mixture of B and 4B for the middle tones, and the 4B for the darks.

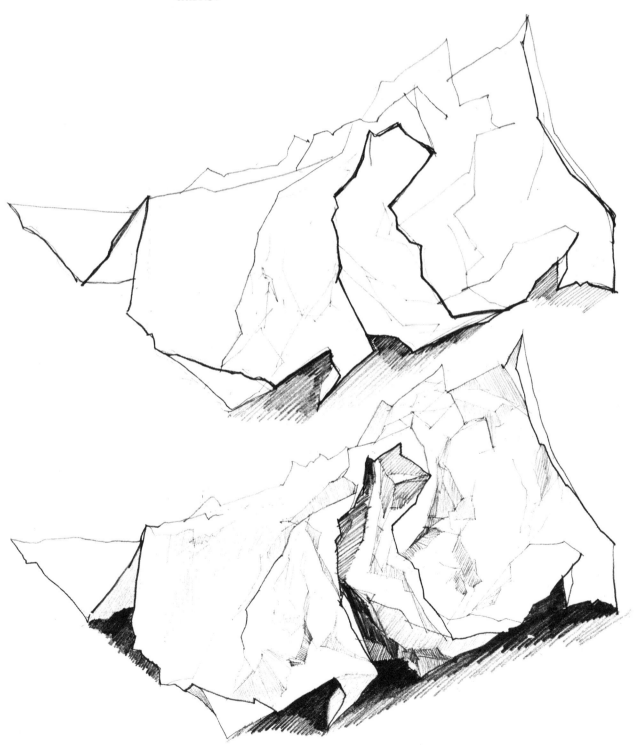

Variety of subject and technique

Here are two drawings of the same subject drawn from different positions. I have used black and white Conté pencils on grey Ingres paper.

Before commencing a drawing, decide whether the subject fits better on a vertical or horizontal piece of paper.

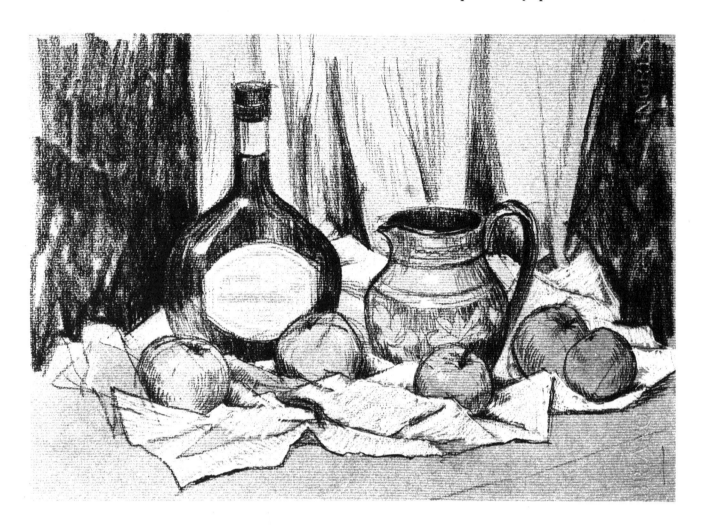

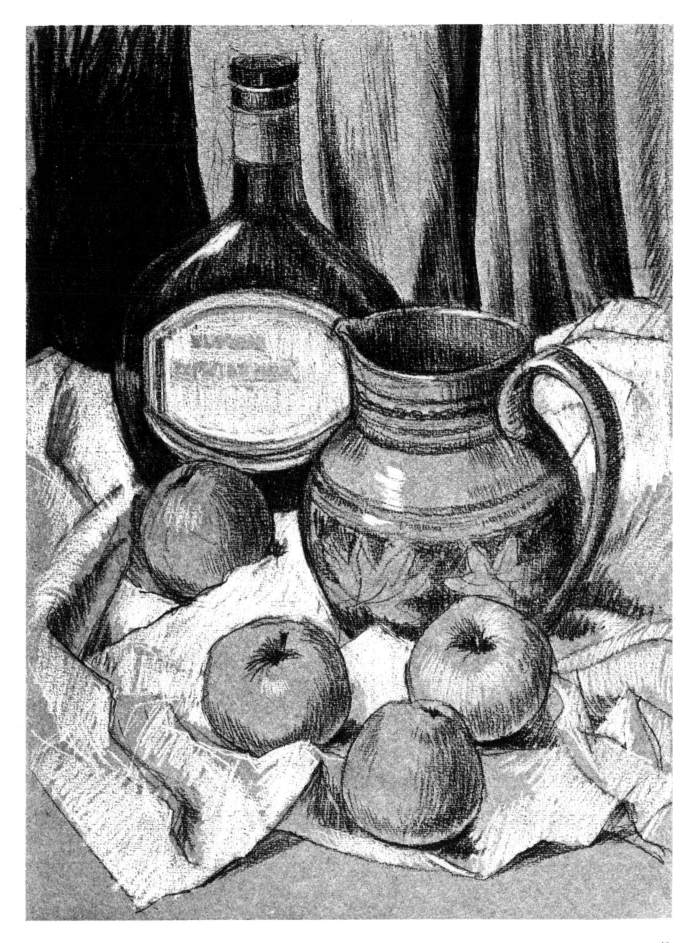

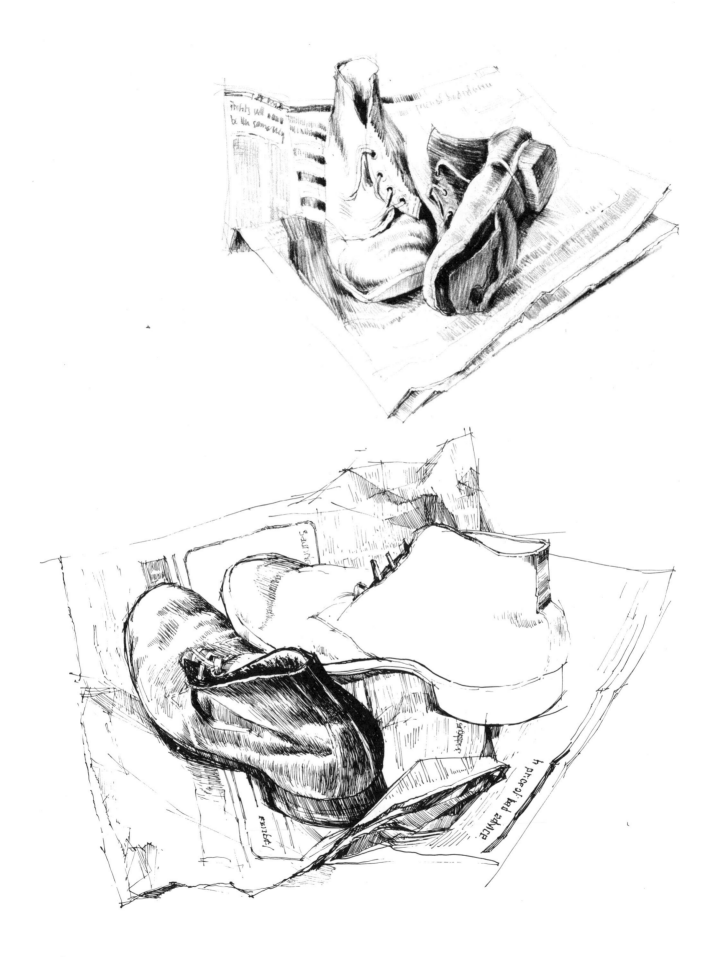

These old boots on a newspaper were interesting to draw in different media. A 2B pencil was used for the drawing at the top of the page opposite, and the one below it was drawn directly with pen and ink. A grey Conté pencil was used for the drawing on this page.

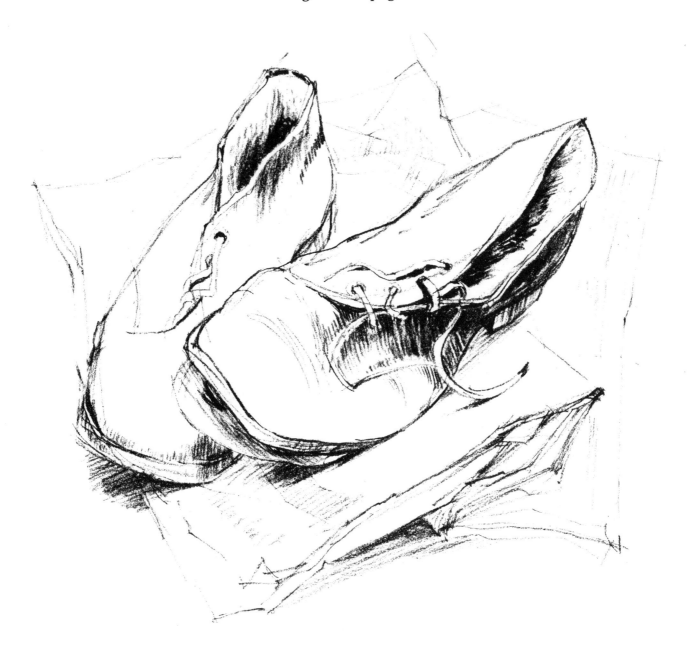

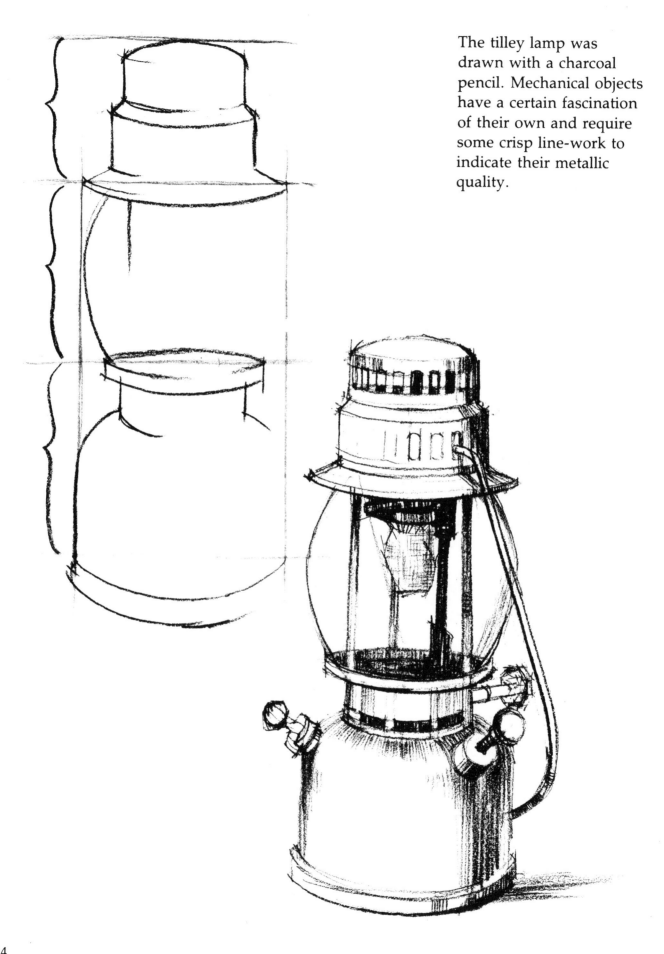

The tilley lamp was
drawn with a charcoal
pencil. Mechanical objects
have a certain fascination
of their own and require
some crisp line-work to
indicate their metallic
quality.

These overlapping chairs, also drawn with a charcoal pencil, make an interesting linear pattern. They present a few problems of perspective. It helps to make floor 'plans' when drawing the legs.

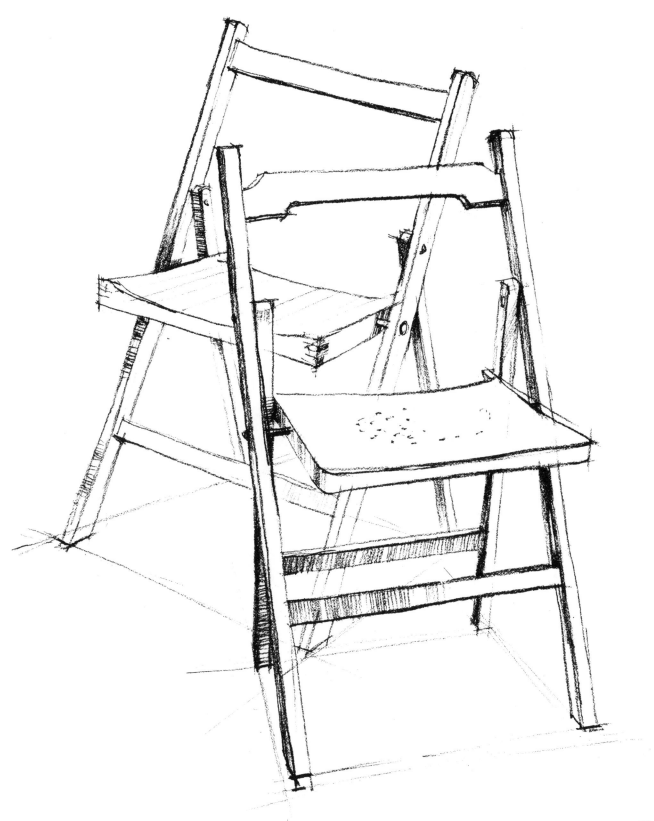

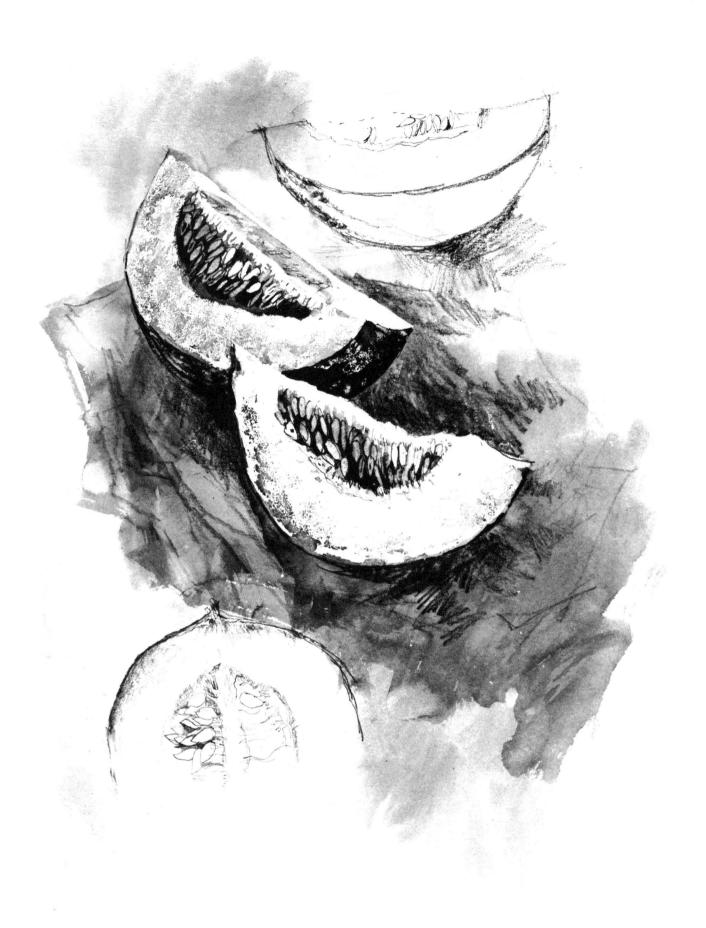

The studies of melon slices (opposite) were made with a 2B pencil, masking fluid and watercolour wash. I then used them to make a more imaginative charcoal drawing (below), looking for the repetition of shapes, the pattern of tone, and making my own arrangement of the subject matter.

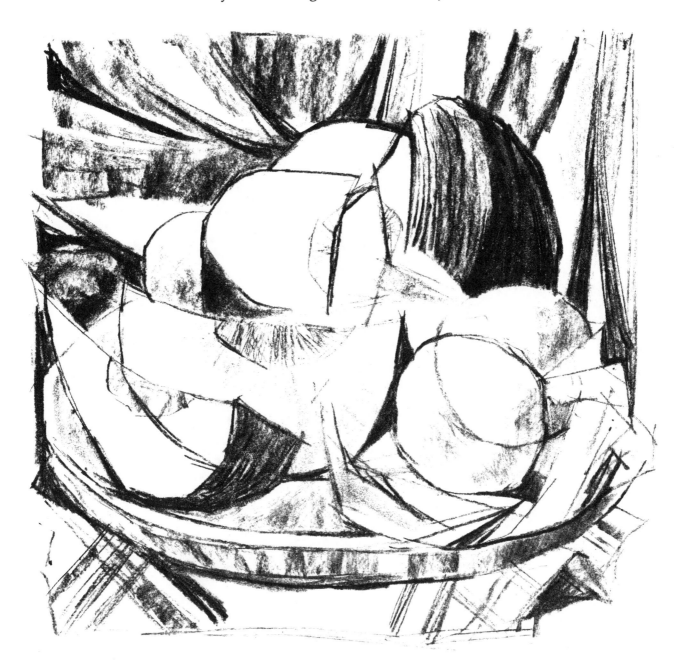

Look at still life paintings by great artists. Most of the objects that provided them with inspiration are everyday things that can be gathered together at home. Overleaf is a drawing of the same simple objects that Chardin used in one of his paintings.

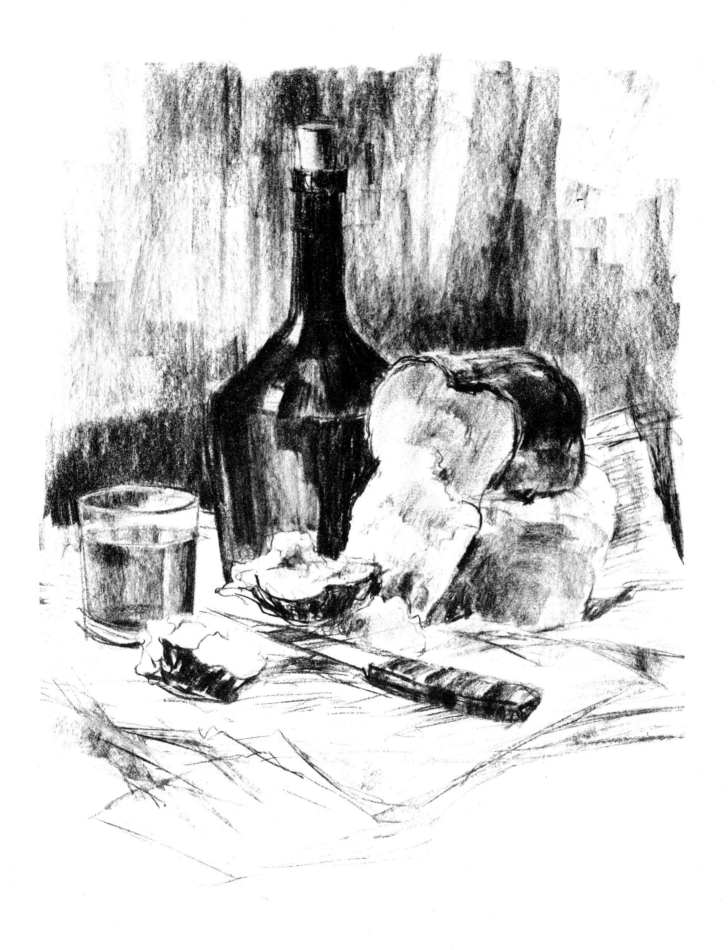